The North Light
Guide to Painting Skies

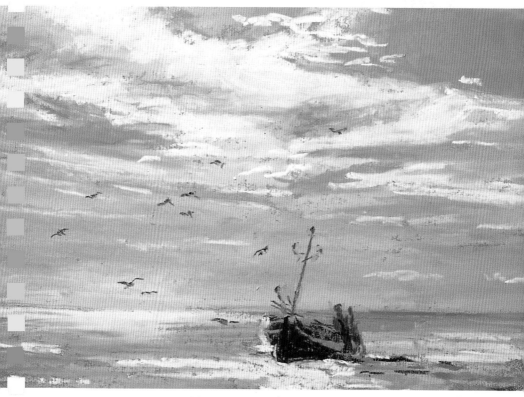

Patricia Seligman

NORTH LIGHT BOOKS
Cincinnati, Ohio

A QUARTO BOOK

First published in North America in
1997 by North Light Books, an
imprint of F&W Publications, Inc.,
1507 Dana Avenue,
Cincinnati,
OH 45207
1-800-289-0963

ISBN 0-89134-779-8

This book was designed and produced by
Quarto Publishing plc
The Old Brewery
6 Blundell Street
London N7 9BH

CONTENTS

UNDERSTANDING THE BASICS

SKY DIRECTORY

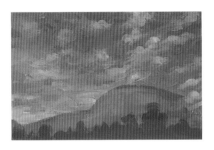

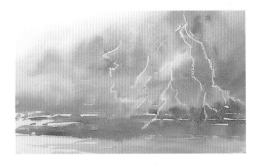

UNDERSTANDING THE BASICS

Artists who paint the world around them will paint the sky and it is for many the fount of all inspiration. Light emanates from the sky so it sets the tone and the overall cast of color for the rest of the painting. In addition, the sky can set the temperature and the mood of the painting. Clouds too can dominate or complement the composition.

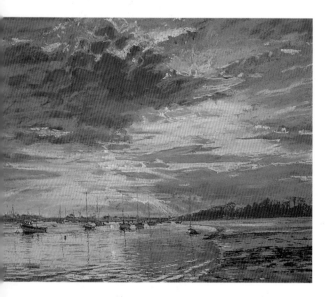

▲ *Margaret Glass,*
Sundown, Rambholt,
pastel. An evening
sunset illuminates banks
of stratus.

CLOUD SHAPES

At any one time many different types of clouds may be visible in the sky, giving the artist licence to choose what suits him or her in any skyscape. "Inventing" clouds is hard work and can produce dull results, so go to nature for ideas and see how quickly cloud shapes disappear and reform, driven by wind and other forces, providing an ever-changing catalog of inspiration.

Where clouds are concerned, you can survive quite happily as an artist without knowing the particulars, but it can help to recognize the characteristics of clouds. Clouds are formed when rising air cools in the upper atmosphere causing water vapor to condense into droplets of water. These gather together to form clouds and eventually fall as rain, hail or snow. There are three main types of cloud: *cumulus* (low, heavy, piled high); *stratus* (low and monotonously layered); and *cirrus* (high and wispy).

Stratus

Uniform banks of layered gray clouds which usually bring dull days and maybe some drizzle. On such "dull" days contrasts are reduced and this creates its own challenge. Such gray skies do not have to be dreary, however, as the examples in the Directory show.

Cumulus

The larger, more plastic, clouds usually seen in the lower levels, herald showers in a blue sky or more heavy weather when amassed together. Take care not to model them too carefully or they will appear to come forwards from your landscape. Cumulus are useful in a

▶ Altostratus in the mid-levels.

▲ Patterns of cirrus clouds in the high levels.

◀ Cumulus clouds also appear in the high levels.

composition as they can be used to echo shapes in the landscape.

Cirrus

Light wispy clouds in the upper levels sometimes described as "mare's tails" or a "mackerel sky." Cirrus clouds are diffuse, so they are usually seen masking a blue sky.

These cloud types can be found at three levels: low, prefixed by *strato* as in *stratocumulus*; mid, prefixed by *alto*, as in *altostratus*; and high, prefixed by *cirro*, as in *cirrostratus*. *Nimbo* added to these categories describes them in the process of precipitation—raining or snowing.

LIGHT

Light emanates from the sky and is then reflected off surfaces in the landscape below. The quality of the light changes according to the weather, time of day, season and the geographical location. Judging this quality of light will help you capture the essence of a scene.

Strength of light

The sun gets stronger as it rises in the sky. It is strongest of all in midsummer and near the equator and weakest in the winter. The density of the cloud cover will affect the

▲ *B. Eisenstat, Evening, Poole Harbor, casein. Pink evening light permeates this painting.*

▼ *A gray overcast evening is lit up by a burst of sun through a gap in the clouds.*

strength of the sun, so that a dull light emanates when there is heavy cloud cover and the brightest light when the sky is clear. Remember that white snow reflects light so that it appears almost blinding.

Color of the light

The light from the sky also changes in color to qualify all you can see. You will find pale pinks in the early morning, golden yellows on a summer's evening, cold blue light and surreal green light. The color of the light can be seen in the sky, affecting the quality of a blue sky and tinting clouds and can be used by the artist to set the mood of the painting.

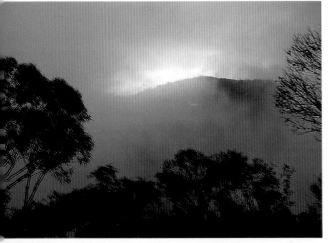

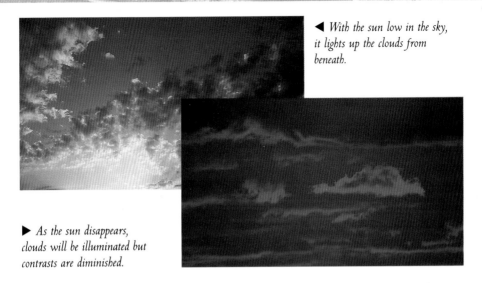

◄ With the sun low in the sky, it lights up the clouds from beneath.

► As the sun disappears, clouds will be illuminated but contrasts are diminished.

Position of the sun

When you start painting a skyscape, first of all locate the position of the sun as this will help you to understand the state of your clouds. The extent to which clouds will reflect the sun or occlude it will depend on their density (see previous pages). With the sun behind but up above heavy clouds, the tops will appear white with darker gray shadows beneath. With the sun going down below the clouds, they will appear lighter below and darker above. When the sun is hidden, the clouds appear flatter with less contrast of tone. The most dramatic clouds are heavy clouds such

as *altocumulus*, with their faces lit up by the sun above. The sun itself becomes part of the skyscape, breaking through cloud cover in a shaft of light or lingering on the horizon, blood red, before dusk.

▲ *R. Jesty, Clouds dissolving, Hartland moor, watercolor. The sun behind these clouds lights up their wispy outer edges.*

LIGHT QUALITY

These photographs show how the quality of the light—its strength and color—can affect the sky and how it appears to the painter. You can see how these different lights permeate the mood of the painting, and because it has such an influence on the rest of the painting many artists like to get the sky right first.

Try painting the same scene in different lights and see how it changes in character and mood. Note, too, how the sky is tonally lighter than the landscape.

▼ *A moment of utter stillness in the early morning misty light.*

▼ *Fair-weather cumulus in the high levels changes shape as it is blown across the clear blue sky.*

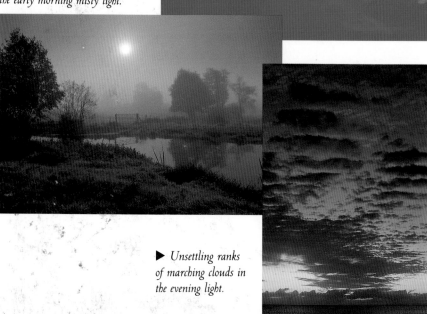

▶ *Unsettling ranks of marching clouds in the evening light.*

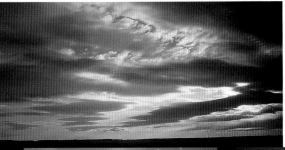

◄ *Shape and color combine for a perfect composition.*

▼ *A full-blooded sunset has to be treated with care by the artist.*

▲ *The artist will need to introduce color into photographed cloud grays so that such dramatic backlit clouds as these can realize their full potential.*

▶ *A rainbow is a test for any painter (see p.60).*

9

USING COLOR - BLUES

A blue sky will appear drab and lifeless, affecting your landscape, if it is painted one flat color. There are examples of how to enliven your blue skies in the Directory, but first you will have to choose the color and tone of your blue. Rather than using a blue straight from the pan or tube, modify it with other colors, e.g. add red or yellow, or dull it with a touch of Payne's gray.

Ultramarine, cobalt, phthalo, and cerulean are the most commonly used blues in every medium. In watercolor,

▼ See how many sky blues you can achieve by mixing a range of blues with red, yellow and Payne's gray.

Ultramarine	Cobalt	Phthalo	Cerulean
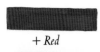			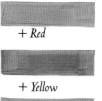
+ Red	+ Red	+ Red	+ Red
+ Yellow	+ Yellow	+ Yellow	+ Yellow
+ Payne's gray	+ Payne's gray	+ Payne's gray	+ Payne's gray

Strong but transparent, rich, warm violet blue. Not reliably permanent but mixes well, meaning that it retains its strength and vibrancy.

Clear, rich, slightly cooler than ultramarine. Semi-transparent.

Very strong, dark greenish-blue. Transparent but use with restraint. The original "Prussian" blue is not stable so the chemical phthalo blue—otherwise known as Winsor blue or monestial blue—has mostly replaced it. Mixes well.

Transparent, cool blue. Perfect for clear weak blue skies. Easily subdued by other colors. Watercolor version does not mix well.

Antwerp blue—a more greeny opaque blue—is described as "well-behaved," meaning that it does not dry too quickly like cobalt, streak or granulate. Gouache colors cater for the designer and include some exotic-sounding colors such as peacock blue. Get to know the basic blues and then branch out if you need to. Pastel colors cannot be premixed and are bought in tints ranging from pale to dark. To start with, for blue skies, try three tints of cobalt and ultramarine as well as some colored gray tints.

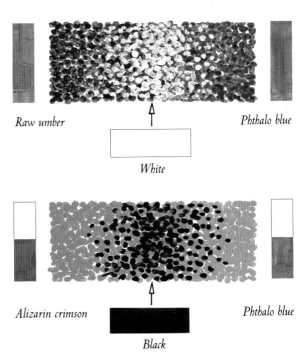

Raw umber *Phthalo blue*

White

Alizarin crimson *Phthalo blue*

Black

Mixing the right blue

Describing the sky as "blue" encompasses a wide range of hues from the rich, dark gentian-blue sky of high summer to the weak, yellow-blue sky of winter. So a blue sky is rarely just a daubing of blue straight from the tube or pan. It is more often a combination of blue with other colors.

When painting a landscape, one way of arriving at the right blue color and tone is by mixing what you think it is and then holding up the brush against the sky. Get the tone right first and then adjust the color. To your tube blue, say ultramarine, you may add another one, say cobalt to cool it, or a touch of alizarin crimson to warm it. You might dull it with a little raw umber, or tint it with some white.

See how many useful sky blues you can achieve with phthalo blue mixed with other colors.

▲ *A blue sky is never a single color, so you will need a range of colors stemming from a base color — here phthalo blue.*

USING COLOR - GRAYS

Clouds are not simply white with gray shadow—they are white tinged with lemon yellow or raw sienna and gray leaning towards violet or ultramarine blue. Indeed, if you bring color into your clouds, you will find they achieve the luminosity of reality. In the Directory, there are examples of clouds lit up by pink and deep yellow light—in fact all the colors of your palette.

Mixing colored grays

Try mixing your grays with colors, rather than mixing black with white. With watercolors, pale washes of transparent paint are qualified by the white of the paper beneath. Cloud highlights are left as white paper with colored grays mixed for the shadows. With opaque media, clouds are built up from dark to light with shadows balanced tonally by the highlights added last. But lively grays can be achieved through broken color and optical mixing on the canvas or support; through glazing

▼ *Mary Ann Pope, Santa Fe Sunset, watercolor. Although clouds sometimes appear to be just dull gray, mix colored grays to tie them in with the landscape and to make them more lively.*

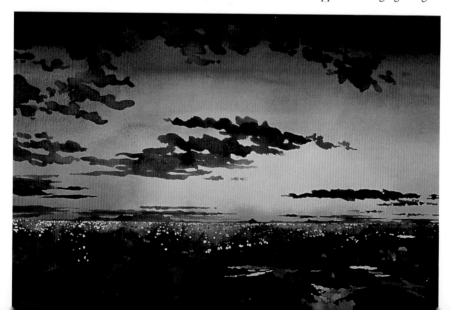

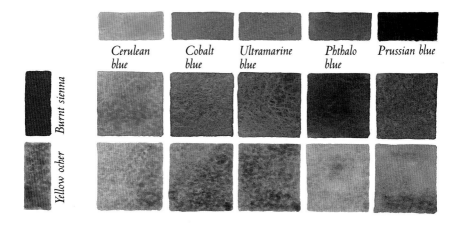

Cerulean blue Cobalt blue Ultramarine blue Phthalo blue Prussian blue

Burnt sienna

Yellow ocher

▲ *Try mixing blues with colors such as yellow ocher and burnt sienna to create a range of grays.*

transparent colors over one another; and through stippling, dry-brushing and scumbling, as demonstrated in the Directory.

Complementary colors

Complementary colors, those that are opposite each other on the color wheel, such as yellow and violet or orange and blue, appear particularly vibrant when placed next to each other in a painting. You need not use them fully saturated—a mere touch in a white highlight will produce a more lively area of paint. Juxtapose highlights tinged with orange with a backdrop of blue sky and see for yourself. Try lemon yellow highlights in a cloud with violet grays in the shadows.

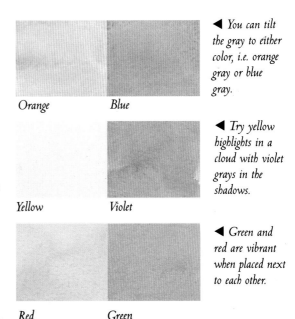

Orange Blue

◀ *You can tilt the gray to either color, i.e. orange gray or blue gray.*

Yellow Violet

◀ *Try yellow highlights in a cloud with violet grays in the shadows.*

Red Green

◀ *Green and red are vibrant when placed next to each other.*

13

CLEAR SKY

Painting a clear sky may seem like an easy option for the artist, but the sense of infinite space of a pale evening sky, or the pulsating heat of a deep azure summer sky, is not so simple to convey. One flat layer of paint is seldom enough. You can superimpose layers of transparent watercolor or with feathering strokes interweave various shades of blue pastel. Building up color in this way will increase the depth of the color. Whatever the state of the sky, the artist must determine the position of the sun to evaluate the focus and direction of the light source.

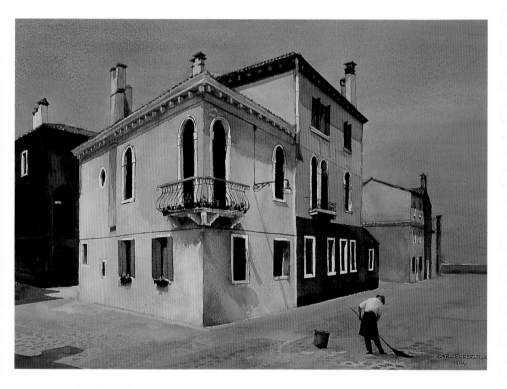

▲ *Carl Podszus, Blue house, Burano, watercolor. The intensity of the hot ultramarine sky is enhanced by the contrasting cool blue of the house.*

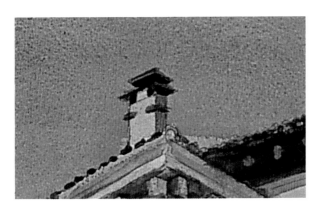

◀ Shadows on the side of the chimney and under the eaves of the roof indicate the direction of the sun, which is shining directly onto the lighter surface. They also give the building its three-dimensional appearance.

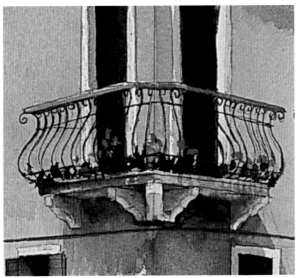

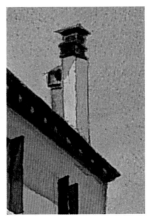

▲ There is a subtle variation of tone within the shadow, with the darkest blue immediately underneath the balcony and lighter shades graduating down the wall. After applying a strong blue for the darkest tone, the artist diluted the paint with varying amounts of water, and then applied the shadow with small brush strokes.

▲ The deep shadow under the eaves, and the carefully observed shadow tones on the chimneys, convey the strength of the sunlight in this scene. Notice how effectively the warm, orange-red comp-lements the blue of the sky.

Sun Below the Horizon

With the sun below the horizon, the sky will carry the light and color while the landscape lies in monochrome darkness—an opportunity not to be missed for the sky artist. Early morning light is often tinted pink or yellow, but paler than the evening light and usually with less heat, whatever the time of year. For skies of any sort, the watercolor artist needs to master the art of applying a wash. Superimposing washes enables you to build up a depth of color gradually, achieving in this case a brighter, warmer area of color on the horizon.

TIP
The pale yellow morning light is suggested with an initial gradated wash in a mixture of lemon and Winsor yellows to make a cool, acid color.

CLEAR SKY

Superimposed washes

1 *Over an inverted, dry, gradated wash of cool yellow, add another of cobalt blue, tilting the board as you apply the paint.*

2 *Cobalt blue dries quickly, creating the striped effect with each successive stroke across the paper. This gives the sky a vibrant "buzz."*

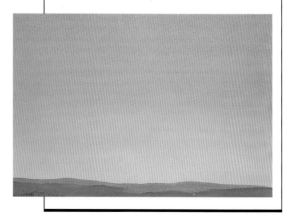

CLEAR BLUE ALPINE SKY

As we have seen, a blue sky is not a single shade of blue. It is dome-shaped and its blueness is affected by particles in the air, making it more intense and warmer overhead and paler and cooler towards the horizon. With gouache, color and tone can be intensified by superimposing layers of color wet-on-dry until the desired tone is reached. Superimposed washes can be broken, as here, to introduce streaks of light on the horizon.

TIP

The snow-capped mountain is reserved with masking fluid before applying the first overall variegated wash from blue to pink.

CLEAR SKY

Building up tone

1 Take the first ultramarine and cerulean blue wash down the paper, adding a little crimson.

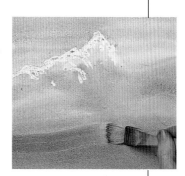

2 A second streaky wash over the sky increases the tone. Darker blues are added wet-in-wet for the shadows.

3 Having removed the masking fluid, the mountain tops appear to reflect the pale pink light in the sky.

HEATWAVE BLUE SKY

When it is really hot and the sun is high, the sky seems to pulsate with the heat. You can hint at such intensity, in whatever medium, by painting the sky with small energetic brushstrokes. If using acrylics, paint a flat area of blue and then tiny horizontal strokes of turquoise and pink over the top. Here, the heat is expressed through the power of color. The intensity of the hot blue sky comes from the underpainting of complementary colors. Gouache paints allow you to paint light tones over dark, and the velvet-like depths of the colors are particularly suited to this up-tempo painting.

TIP

With gouache, dilute the paint with less water as you build up layers. This will ensure that superimposed paint does not disturb the paint layers below.

CLEAR SKY

Vibrant color

1 *Lay down washes of complementary colors—yellow ocher for the blue sky, lemon yellow for the sea and ultramarine for the foreground.*

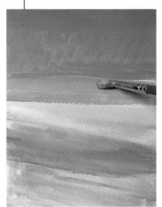

2 *Starting from the top, overpaint the sky with ultramarine and phthalo blue, working the paint into the yellow wash more as you come down to the sea.*

3 *Add the tropical sea—viridian and phthalo blue— over the yellow, merging into orange sands— cadmium red and yellow, with white.*

BLUE WINTER SKY

A sense of depth in a painting is lost if the sky is painted in a flat manner. You can give the impression that the sky is overhead and stretching into the distance by manipulating the temperature of the sky colors. Warm colors tend to come forward in the picture plane, and cool colors recede. Here the artist uses warm blues overhead and cooler blues in the distance. These blues are then blended together.

TIP

On non-abrasive pastel papers, other methods of blending can be used—a paper stub, or torchon, or a brush.

CLEAR SKY

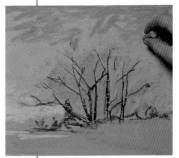

Blending

1 Using an abrasive, mid-tone, fine glasspaper, the artist builds up the sky color—pale and cool on the horizon, stronger and warmer overhead.

2 When working on abrasive paper, blend colors by working one into another. Fingers can be used for final touches. Take care not to overblend.

3 A pale violet blue is used to echo tree forms in the sky, thereby helping to integrate tree and sky.

19

RED SKY AT NIGHT

Fiery sunsets are difficult to capture because in reality they are fleeting spectacles which you have to "catch." So when painting them remember to hint at the movement and the incandescence. With acrylics, the blending of one hue into another can either be worked into a smooth gradation of color and tone or, as in this example, the colors and brushstrokes can be preserved to suggest movement and infuse the painting with a vibrancy of light.

TIP
Note how the canvas weave breaks up the brushstroke to allow glimpses of the white primer to break through in places, adding a further shimmer of light.

CLEAR SKY

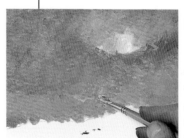

Lively brushstrokes

1 *Starting from the sun, work outwards with small lively strokes, laying them one into another.*

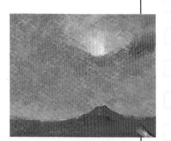

2 *Vary the mix as you go, adding alizarin crimson to the yellow and then ultramarine blue.*

3 *In contrast, treat the landscape with smooth, neutral blue-pink grays, before returning to highlight the sun with pale lemon yellow.*

GOLDEN LIGHT OF A SUMMER'S EVENING

As the sun goes down, the contrast between the blue "top" of the sky and the pale light on the horizon, close to the sun, increases. On a golden summer's evening the cast of light in the lighter areas will take on a glowing hue and can be worked into the rest of your picture as highlights, uniting sky with landscape. With watercolor, you can flood the painting with golden light by taking a first wash of yellow down from the sky under the landscape.

TIP
When painting watercolor skies, you will achieve a more vibrant depth of color by building it up with a number of superimposed washes.

CLEAR SKY

Taking wash under landscape

1 Apply the first wash in merging bands of dilute yellow, taking it down under the landscape.

2 Once the first wash is dry, add another with more red, adding a little blue toward the end.

3 Finally the landscape is added in broken washes, but the whole painting is permeated by the golden light of the first washes.

LIGHT CLOUD

Light clouds can be found in the sky at any level in any weather. For the artist they can be useful as part of the composition and also provide a chance to break up an expanse of sky. A combination of light cloud and wind creates dappled skies, mares' tails, or mackerel skies – effects which can test the artist. As light clouds are often seen as a soft layer of white over blue, with opaque media, scumbling and dry brush techniques are useful.

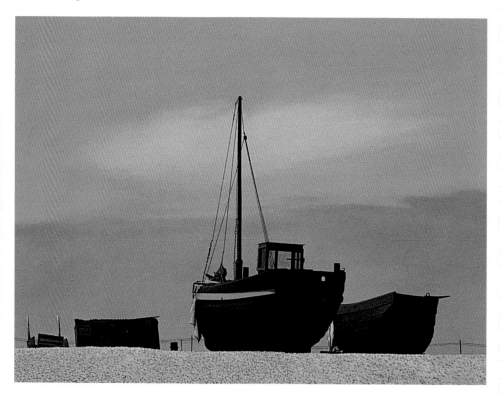

▲ *Brian Yale, Resting boats, acrylic. The stillness of the resting boats is offset by the lively cloud which holds the center stage.*

◀ The soft edges of this cloud were applied with even horizontal strokes fading into wispy streaks. To achieve this effect, the white cloud was applied over the pale cobalt blue while the paint was still slightly wet. The artist has blended semi-opaque white paint with a touch of yellow to suggest a hazy summer cloud.

▶ This dramatic juxtaposition of light and dark tones has a strong impact and indicates a bright, clear light quality. The luminous blanket of pale cloud showing through the negative shapes of the boat accentuates the detailed outline of the boat silhouette. Notice how the horizontal line of the cloud cuts into the vertical mast to break up this negative shape.

APPROACHING DAWN

The main effect here, where the rising sun stains the sky on the horizon and the wispy mid-level clouds, is of the light shining through. Note how the clouds are made to recede by toning down, or knocking back, pure color in the distance and leaving it strong and intense in the clouds overhead. Warm colors have been used in the cloud mass and in the blues around the clouds overhead, and cooler yellows, oranges, and blues have been used in the distance.

TIP

On highly abrasive paper, pastel colors blend and are softer the more they are built up. Stark marks should be made on fresh paper.

LIGHT CLOUD

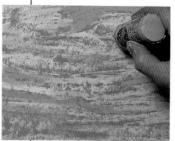

Knocking back color

1 Lay down the areas of color in chalk pastels onto brown–tinted fine, abrasive glasspaper, darker colors first.

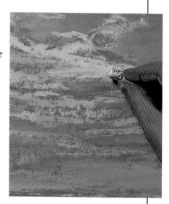

2 Build up color. Remember that the main effect is the light shining through.

3 To create recession, colors are toned down in the clouds in the distance by superimposing white and cool grays.

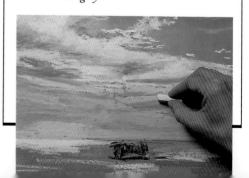

MACKEREL SKY

High, wispy cirrus is sometimes broken up by the wind to form what is called a "mackerel sky." In the early morning, the sky will take on a cool yellow tinge, increasing towards the horizon. With opaque paints, add the vaporous clouds with a very dry brush into the blue before it dries. For watercolor, try this method of superimposed broken washes.

TIP

For watercolor washes, you will find it easier if you first tape down your watercolor paper to a board with masking tape.

LIGHT CLOUD

Superimposed broken washes

1 *Allow a yellow wash to dry, then wet with water. Now add dribbles of Antwerp blue. Tilt to right and then left.*

2 *When dry, repeat the same method for the broken wash above, this time with Payne's gray. Don't paint too densely and vary the application.*

3 *As the wash is merging, control the direction by tilting the paper. Correct overruns by taking off the paint with a dry brush.*

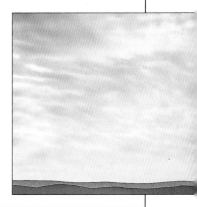

HORIZON CLOUDS

Clouds which brew up on the horizon with a weak sun overhead will have a sharp top outline but will lack any detail of form. Watercolor washes can be applied in small patches, wet on dry, which gives them a hard edge. Superimposing such washes can create subtle variations in tone.

TIP

An edge which dries too hard in watercolor can be softened by taking a clean brush dipped in clean water and gently worrying the paint along the edge, before blotting it with kitchen paper.

LIGHT CLOUD

Superimposed washes, wet-on-dry

1 *Follow the cloud sketch, leaving a space of white paper between sky and cloud.*

2 *Apply a cool gray wash, the same mix as above but with more gray. Don't worry if it is not even: clouds rarely are.*

3 *Once the gray wash is dry, add further patches of a warmer gray— Payne's gray and alizarin crimson —which will come forwards from the blue-gray.*

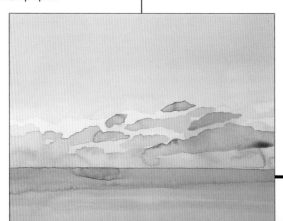

RACING SUMMER CLOUDS

A windy day in the summer with a few white clouds scudding along requires some suggestion of movement in the painted surface. Soften the edges of the clouds as if they were seen in a blur as they rushed past. You can do this by building up layers of semi-opaque paint—acrylics are used here—allowing the darker underpainting to show through the broken color applied wet on dry, suggesting the ever-changing cloud forms.

TIP

With water-based paints, you can speed up the drying process with a hairdryer. Moderate the heat and do not hold it too close or you may damage the paint surface.

LIGHT CLOUD

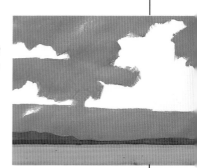

Semi-opaque layers

1 *The blue sky is laid down leaving rough-edged areas of white for the clouds.*

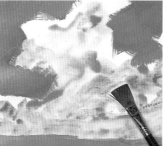

2 *Now the tonal nuances of the cloud are suggested with a dilute blue-gray, rolling the paint on and encouraging contrasts. Allow to dry.*

3 *Applications of white, thinly veiling the grays, are then qualified with darker gray shadows and thick white highlights.*

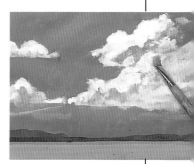

27

PINK CLOUDS IN A BLUE SKY

The sky often goes unnoticed as if nature is playing to an empty house. But sometimes the show is so spectacular that we cannot help but notice—e.g., when the sun disappears from view below the sky line to leave banks of pink-tinted clouds hanging in the sky like balls of candyfloss. It is such surprises that attract the artist, but prettiness of this kind is difficult to paint without sentimentality. It usually pays just to hint at nature's wilder shows, leaving the imagination to fill in the rest. Dry-brushing pale paint over the background sky will produce some suitably fluffy clouds.

TIP

Keep a "sky diary" recorded from a window where you can view the sky in peace. Do small sketches, paintings and add photographs and magazine clippings.

LIGHT CLOUD

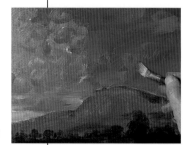

Drybrush

1 *The movement in the sky is suggested with broad, expressive brushstrokes.*

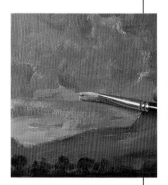

2 *A thicker mix of pale orange is applied with a clean, dry brush so that the paint stroke is broken, allowing the shadow colors to show through.*

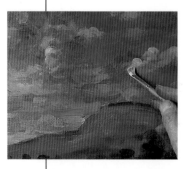

3 *Pale pink drybrush creates the candyfloss clouds: the thick paint is touched on and dragged across the canvas weave.*

EVENING SUNSET

As the sun sets, the sky changes through a subtle rainbow of colors radiating from the horizon. With a variegated watercolor wash, these shades can be added by dropping on color as you work downwards. You can tilt the sheet to move the paint around in an attempt to control what is at first a very ad-hoc technique. Remember that washes dry paler so they can appear worryingly bright when first laid down.

TIP

If you have been overadventurous with your colors, and are using good quality watercolor paper, you can put the whole sheet under a faucet of cold running water to wash off some of the color. It is a good idea to try this out, and to note the effects, before you are driven to it by circumstance.

LIGHT CLOUD

Variegated wash

1 *Wash the paper with clean water and drop in cadmium yellow, scarlet and alizarin crimson.*

2 *Add cobalt blue and a little Payne's gray. Control the wash by tilting the paper and taking paint off with a dry brush.*

3 *You can see how it dries paler and softer. Add the landscape wet-on-dry— Payne's gray with scarlet—in two washes.*

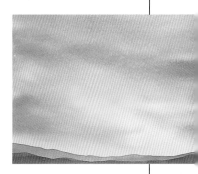

DENSE CLOUD

Dramatic "anvil" clouds which herald a bad storm, or cumulus in a summer sky, are clouds which have substance and depth. They have the ability to impose themselves on your view, forcing you to take notice of them. Such clouds ask for bolder treatment, thick impasto strokes of oil or acrylic, or heavily blended areas of pastel. Heavy clouds will of course affect the quality of the light, creating dull days or dramatically dark stormy nights.

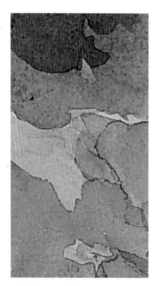

▶ *The pool of shimmering light reflected from a bright part of the sky breaks up the dark expanse of water effectively. The artist painted this area with Payne's gray, leaving specks of white to show through the darker wash of shadow on the water. Flecks of gray, representing ripples, were added with a smaller brush.*

▲ *The shapes of these storm clouds are clearly defined, with separate washes of color applied wet-on-dry. The darkest gray cloud was a mixture of the ultramarine and burnt sienna in the neighboring clouds.*

▲ *Strokes of gray painted over a pale wash in increasingly dark tones capture the movement of billowing storm clouds.*

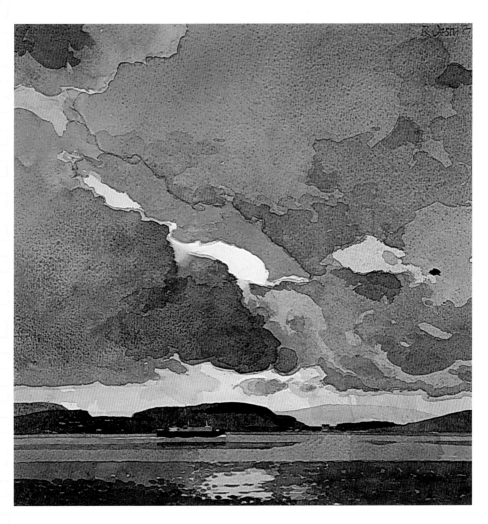

▲ *Ronald Jesty, Out of Oban, watercolor. Dramatic storm clouds are seen in high focus with exaggerated color.*

HORIZON STORM CLOUDS

In the early morning, with the sun low in the sky, heavy storm clouds on the horizon will lack strong definition. With watercolor, you can create such clouds by lifting out cloud shapes with a tissue. This takes a little practice but the results are immensely satisfying once the technique has been mastered.

TIP
Use Antwerp blue for the blue of the sky as it does not dry as quickly as the others and therefore gives you more time to work.

DENSE CLOUD

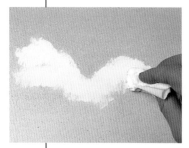

Lifting out with a tissue

1 *Lay down two superimposed gradated washes. With a crumpled tissue lift out the cloud shapes.*

2 *Take care to crumple the tissue into a cumulus cloud form and turn it over when it is soaked with paint.*

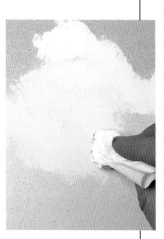

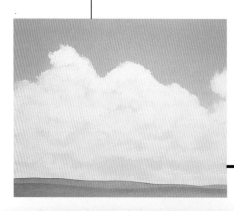

3 *Use a clean tissue surface and more pressure for areas of highlight and less pressure for cloud shadows. Change direction to vary the shape.*

STORM GATHERING AT SUNRISE

The sun back-lights the gathering clouds, creating high contrasts and emphasizing their movement. Clouds are a good subject for *alla prima* painting with oils. John Constable's cloud studies were painted in this way, in one sitting, capturing the immediacy and movement of the clouds. The secret is to keep the mixes fresh and the brushwork lively, taking care not to sully the colors by overworking the paint.

DENSE CLOUD

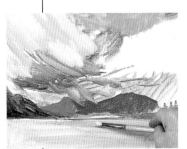

Alla prima

1 *Block in tone and color* with paint diluted with turpentine or denatured alcohol, searching out movement with broad strokes.

2 *Build up lighter,* thicker paint into the underpainting, remaining aware of the focus of light. Don't overwork the paint and keep your brushstrokes intact.

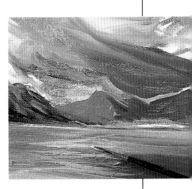

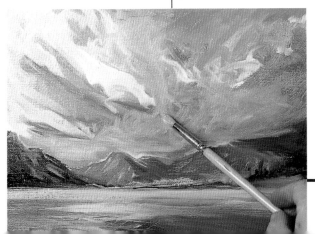

3 *The artist has captured* the colder morning light with cooler complementary lemon yellow and violet.

SEASIDE CLOUDS

Summer clouds in a blue sky can be hard to paint. Try building up the shadows and highlights first in watercolor, wet-on-wet, and then add the blue sky, wet-on-dry. Vary the edges by making them crisp where the sun reflects from the tops of the clouds and blot the edges with tissue where it should be softer.

TIP

When you are lifting off paint with a tissue, remember to turn it over as you lift it off to present a clean dry area as you press down again.

DENSE CLOUD

Varying the edges

1 Mix a warm gray with ultramarine blue and light red and feed it on for the cloud shadows. Blot off with a tissue.

2 When dry, paint in the cobalt blue sky, wet-on-dry, creating the starkly lit top edges of the clouds.

3 To suggest movement, the cloud edges are softened in places, by loosening the paint with a wet brush before blotting with a tissue.

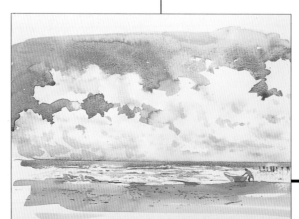

STORM CLOUDS

Massive three-dimensional clouds do instil a sense of foreboding as they tower above you. Take care not to overdo the solidity of such clouds, remembering that they are made of vapor and not solid matter. Pastels make gentle marks although they can be built up to form solid color. Try building up the base colors with flat areas of blended pastel strokes, and then suggest the form with more graphic strokes superimposed. Build up the mid-tones first, adding highlights at the end to give your painting a sense of vibrancy.

TIP

To leave a strong touch of color on the paper when working with pastels, slightly twist the stick as you lift it off.

DENSE CLOUD

Adding highlights

1 *Following a pastel sketch, on tinted glasspaper work on the mid-tones, modeling the cloud formation.*

2 *Continue building up tone, keeping the edges of the cloud soft. Now add white highlights, pressing down and pulling off abruptly for a strong touch.*

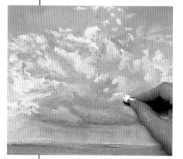

3 *Return to the rain dropping from the cloud in the distance and develop it with vertical strokes. Finally, emphasize the scale of the cloud.*

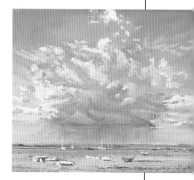

WIND-WHIPPED CLOUDS

With the sun dipping below the horizon in the evening, wind-whipped storm clouds sometimes take on an ominous hue. You will find that certain mixes of watercolor granulate into a textured wash which is useful for cloudscapes. Payne's gray and ultramarine blue are both granulating agents when used in a mix. Here two red-gray mixes are made with Payne's gray and light red, one redder than the other.

TIP
New gamboge yellow is a warm, transparent yellow which goes on evenly, dries quickly and works well in washes.

DENSE CLOUD

Granulation

1 Allow a wash of new gamboge to dry and rewet before feeding in the two gray mixes. Tilt the board diagonally.

2 You can manipulate the wash with a clean brush to redirect it or, as shown here, to add movement to the base of the cloud bank.

3 The wash dries with a strong diagonal movement. Note how the spaces left between the grays result in the lighter patches of yellow.

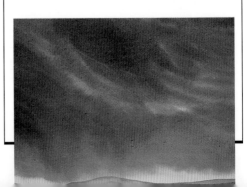

EVENING SNOWSTORM

With the light fading fast, occluded by the heavy banks of clouds and the falling snow, the only place for the artist is wrapped up warmly indoors. When using opaque paints, work from dark to light, rendering the falling snow last. This gives you the opportunity to build up the darks of the prevailing mood of the storm before screening it with touches of light. With pure watercolors, such a scene would be difficult to paint. Touches of snow can be created with masking fluid, but it might be better to concentrate on the moodiness of the scene and the movement of the gusts of snow.

TIP

It is worth practicing spattering first, varying the dilution of the paint, the type of brush and the distance you leave between brush and paper.

DENSE CLOUD

Spatter

1 *First build up a background cloudscape with thin layers of paint, working from dark to light, and diagonally.*

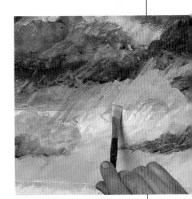

2 *Now mix white with water to form a dilute mix. Using a decorator's brush pull back the bristles from the side for a diagonal spatter.*

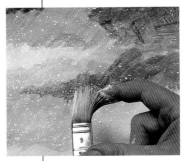

3 *The spatter adds to the drama of the storm, adding movement and exaggerating the contrasts. The specks of snow also unite the surface of the picture.*

LAYERED CLOUD

When you look at the sky it is seldom filled with one type of cloud, but is a combination of, say, cumulus, cirrus and stratus (see p.5). These layers of clouds can also be affected by the artist's view over distance. Standing in one spot, you might see low-lying banks of stratus in the distance, large storm clouds approaching from the north and the remains of the sunny day with a few remaining wispy clouds overhead.

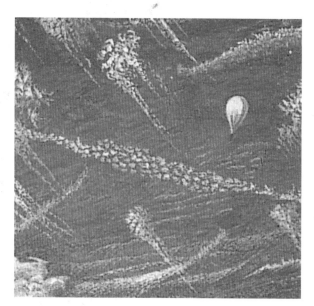

▼ *The blue always appears darkest at the top of the sky, and this glimpse of intense blue beside the brilliant white cloud creates a sense of depth. The mid-tone grays have been worked around the contrasting blue and white to give the impression of cloud layers.*

▲ *Small flecks of cloud were painted with quick, deliberate strokes of pure white over an already-dry sky of cobalt blue. The trails of wispy cloud have been applied with a dry brush dragged in loose ribbons across the blue.*

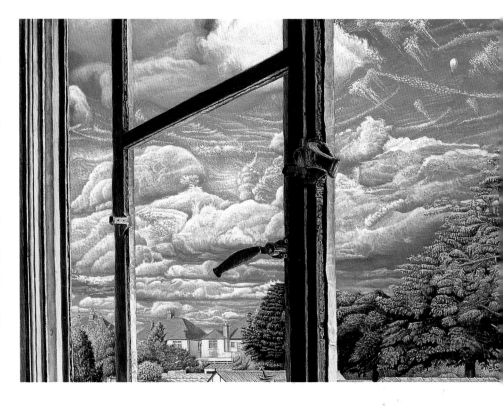

▲ *Paul Bartlett, Beckenham back gardens, oil. Layered clouds receding into the distance.*

▶ *The layers of stratus cloud show yet another cloud effect, with irregular strokes of gray shadow giving a "fluffy" texture. The cloud layers become closer as they near the horizon, creating a dramatic sense of perspective.*

BLUE DAWN

As the cool morning sun comes up over the horizon, the lower layers of cloud reflect the pale yellow and pink rays. Here, the artist turns the rules around making the strong contrasts appear on the horizon, with the top layers of cloud, closer to the observer, only cursorily developed.

TIP

Note how the textured pastel paper breaks up the pastel stroke, giving the impression of light shining through.

LAYERED CLOUD

Focus of light

1 On the pale gray pastel paper, explore the composition and distribution of tone with two blues, one cool and one warm.

2 Build up the contrasts in the dark headland and the focus of early morning light, adding pink to the undersides of the lowest layer of clouds.

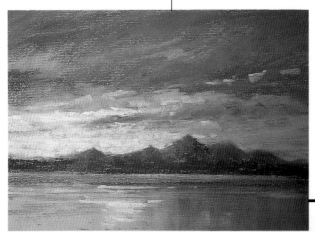

3 Further build up the area around the light, working one color into another and blending with your finger if necessary. Take the pastel lights down to the water as reflections.

CLOUD PATTERNS

A skyscape often has clouds at different levels, varying in density and shape. If you were to paint them as they appeared, the result might be overwhelming. Part of the artist's job is to simplify or edit a scene before painting and this may include deciding on a particular approach. Here the artist has forsaken depth for pattern, exploring these clouds with acrylic paints and a painting knife.

TIP

For a cheap support, the rough side of a piece of hardboard is used here, prepared with three thin coats of acrylic primer.

LAYERED CLOUD

Knife painting

1 *Pick up the paint mix with a small painting knife and then apply, creating the shape by guiding the tip.*

2 *Use the body of the knife to blend the colors. Don't worry if the knife leaves raised edges of paint; these will catch the light and add interest.*

3 *Thicker paint is added for the highlights, altering the pressure of the knife to produce areas of impasto.*

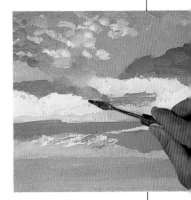

SUMMER CLOUDS

The pleasures of sketching are immediate and long-lasting, as a record and a source of inspiration. With skies and clouds, sketching is good practice for recording something which is constantly changing, communicating a sense of immediacy with a lightness of touch. The scene has to be assessed and simplified. Here the artist relies on stronger contrasts in the sky for a sense of recession, hinting at banks of receding clouds in the background with delicate mid-tones.

TIP

Watercolor sketching has its problems as washes take too long to dry when it is cold and, in hot weather, they evaporate in a flash producing hard edges. Paint bigger and drier (or keep two sketches going at once) in cold weather, and paint small and wet when it is hot.

LAYERED CLOUD

Watercolor sketch

1 Make a quick pencil sketch and then lay down a yellow wash. Apply the sky blue wet-on-dry.

2 Build up foreground detail and then add neutral grays to the cloud shadows to create a sense of recession in the cloud banks.

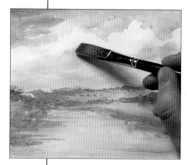

3 As the sun is high in the sky, keep the illuminated top edge of the clouds sharp.

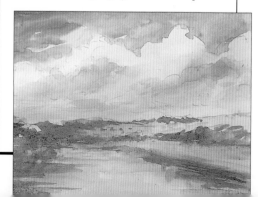

OVERCAST

Layered stratus can bring with it an overcast light with what seem like endless banks of mid-gray stretching to infinity. But this need not be so. Here an underpainting in complementary colors enlivens those grays and the artist makes sure that there is movement, too. As a final touch, a corner of blue sky heralds finer weather and allows the light to be more up-tempo.

TIP

If you are working from photographs, remember that if these clouds appear too solid and sharp-edged, masses fuse and subtleties of color and tone disappear.

LAYERED CLOUD

Enlivening dull grays

1 The first strokes of yellow ocher describe the stratus. A complementary violet gray is worked in wet-in-wet.

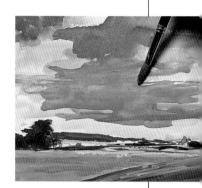

2 Still working wet-in-wet, build up contrasts —darker and paler grays—in the foreground.

3 For the white, billowing cloud in the foreground, wet the area and then feed on thick white with a touch of yellow ocher.

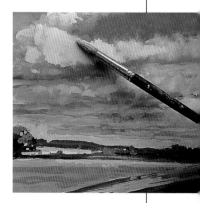

WINTER SUNSET

The sun bursting through layered clouds as it sets might seem like a challenge for any artist. The problem here is to keep the focus of light in the distance as the bright colors will naturally bring it forward. This has been achieved by placing the brighter overhead patch of strong "white" light which comes forward, and by working into, and blending, the yellows and oranges of the focus of light.

TIP
For larger areas, or soft applications, larger sticks of chalk pastel are useful.

LAYERED CLOUD

Focus of light

1 Scrub in the main blocks of color and tone with a large pastel stick. Then start on the focus of light.

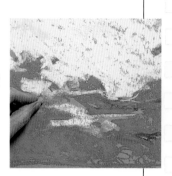

2 Now, lace the forward edge of the forward cloud with palest pink to create depth.

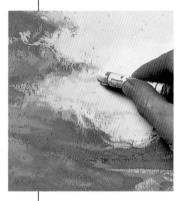

3 Work into the gold striations with cool dark grays to keep the focus of light in the background.

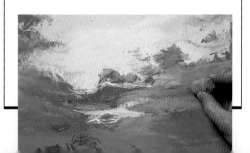

MOON AND CLOUDS

When a full moon bursts through the clouds, a silver light fills the sky and is reflected in the landscape below. The silver light contrasts sharply with the inky black of the night sky, beyond the focus of light. You can build up from dark to light in opaque paints, gradually making the paint thicker towards the end. Lay on these final impasto strokes carefully, balancing their distribution over the picture surface.

TIP

Acrylic paint in tubes is thick, but not all colors have the same consistency. For extra bulk add impasto medium.

LAYERED CLOUD

Impasto

1 Thick acrylic paint retains the mark of the brush. Apply the darks first with a coarse brush, working from different directions.

2 Work mid-tone blues around and into the darks. Note how the light reflects from the ridges in the brushmarks to suggest shimmering light.

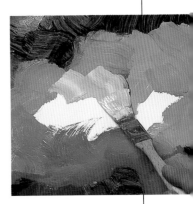

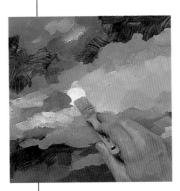

3 Add the moon last, working thick impasto white into the background blue so that it is not too bright, with a single curved stroke.

45

SKY FOCUS

Here we look at sky painting in the context of the whole painting, focusing on a particular aspect of picture making in each of these demonstrations: composing with clouds; perspective of clouds; using color; edges; integrating sky and landscape. The focus of your composition can be emphasized in a variety of ways – through the shape of the clouds, for example, or through patches of color or highlight which catch the eye.

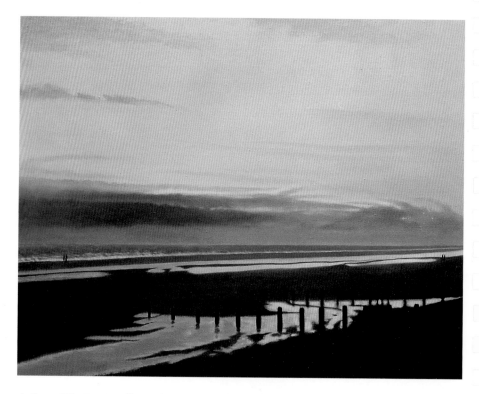

▲ *Brian Yale, Evening falls, acrylic. The sun, hidden by low-lying cloud, lights up the evening sky and is reflected in the water below.*

▶ *This faint, wispy evening cloud is painted with a small brush, using little horizontal strokes. A tinge of pink mixed with the gray reflects the brighter pink streak of sunset below.*

◀ *Interesting variations of color have been blended in this gray cloud. Small, rough strokes of ultramarine blue mixed with raw sienna, and a little naphthol crimson were used for the streak of dark cloud, blending into a pinker mix where the sky meets the horizon.*

▶ *The stretch of water reflects the lighter colors of the sky, with pale yellow around the edge of the water creating a sparkling effect. Notice how the reflections of the wooden verticals do not wiggle, but appear as a simple touch of color immediately beneath the posts, because the water is completely still.*

COMPOSING WITH CLOUDS

Clouds are often moving and so can be "frozen" in your painting to suit the composition. Shapes in the landscape can be repeated in the formation of the clouds, thereby echoing a prominent feature and drawing attention to it. Alternatively, the focus of the composition can be emphasized with compositional lines in the clouds leading the eye to the all-important element. This can be done through the shapes of the clouds, directing the viewer around the picture space, or through patches of highlight or color which again catch eye.

This strong lower edge parallels the horizon, linking sky and landscape.

Exaggerate the cloud edges which lead the eye to focus on the windmill.

The windmill sail overlaps the cloud pushing it into the background.

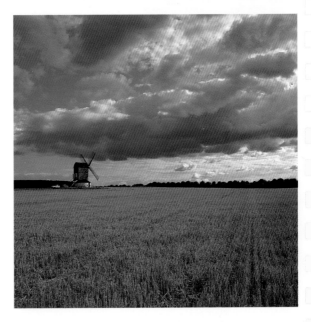

▶ *These dramatic storm clouds automatically draw your eye to the focus of this scene. To paint this picture, the movement of the racing clouds should be exploited with sweeping strokes of paint to give the windmill even more prominence. Notice how effectively the areas of white highlight contrast with the angry gray-reflected shadows under the larger clouds.*

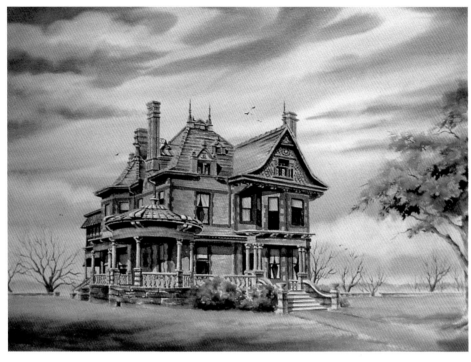

Color in the clouds leads the eye to the house.

Directional lines in the sky "point" to the focus.

Grays in the house are picked out in the sky.

▲ Betty Blevins, Eppleman-McFarlane house, watercolor. These loose, swirling strokes in varying tones and colors force the observer to focus attention on the house. The sweeping central clouds are a combination of yellow ocher, permanent rose, ultramarine and burnt sienna. By introducing these more unexpected colors, a sense of drama is created, making an exciting backdrop for the house.

CREATING PERSPECTIVE

We have looked at how the sky and clouds are affected by aerial perspective in the same way as the landscape. When the effects of aerial perspective are ignored clouds will sit on the picture's surface without any suggestion of recession. If you have treated your clouds too consistently and they all appear to lie on the same plane, apply a thin veil of blue-white scumble with a very dry brush to those closest to the horizon. This will remove definition and detail and knock back the colors.

Keep the colors overhead warm to bring them forward.

Cloud edges form natural orthogonals leading the eye into the distance.

Keep the sun in the background by blending cool colors.

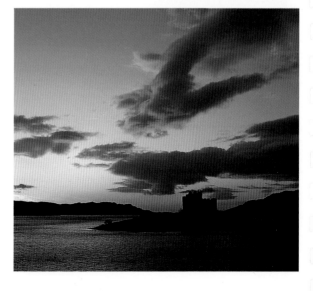

▶ *This beautiful evening sunset gives the strong impression that the clouds are receding toward the horizon. The variation of cloud size and tone gives a sense of perspective, with smaller, paler clouds near the horizon, and the changing tone of reflected light in the water, becoming paler as it recedes, also contributes to this effect.*

▲ *Brian Yale, Faraway, acrylic.*
The smooth, glossy texture of the
water, painted in acrylics,
contrasts brilliantly with the
rougher, paler clouds. White has
been added near the horizon, until
the sky becomes almost white
where it meets the sea. The water
reflects this graded effect, but with
darker tones, to enhance the
perspective. Larger reflected shapes
have been painted in the
foreground in subsequent layers of
deep gray and white, becoming
smaller and paler toward the
horizon.

Although subtly
expressed, colors are
darker and warmer
overhead.

Recession is suggested by
more expressive
brushwork overhead.

Brushwork is smoother
and colors more bleached
on the horizon.

USING COLOR

If you look closely at paintings of skies, you will be surprised to see how many artists have used touches of vibrant color amongst the grays. As the Impressionists taught us, complementary colors can galvanize areas of pale colors too. Touches of palest yellow among areas of a similar saturation of blue, and vice versa, will enliven otherwise dead areas of color. How to mix colored grays for more lively skyscapes is shown on pages 12–13, but remember too that touches of pure color will bring your sky to life and can help lead the eye around the picture.

Although an area of gray in the photograph, paint with warm yellows and blue grays.

Create levels of darkness in this "black" cloud with complementary grays and points of light.

Blend the sunset colors, using cooler lemon yellow and burnt sienna.

▶ *This golden sunset illustrates perfectly the range of color that can be displayed at one time in the sky. Of course, an artist can exploit this array of colors, bringing in even more hues for a truly exciting effect.*

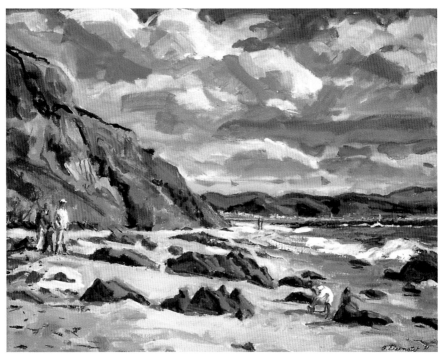

Warm intense blue for a summer sky.

Colors are taken from landscape to sky to link the two.

Pale, neutral complementary purples and oranges enliven the shadows.

▲ Ben Eisenstat, Pillar point, acrylic. Lively brushstrokes express the movement in this blustery summer sky. Grays have been expressed in a wide range of color mixes to reflect the colors of the sea, cliffline and shore, and to capture many different tones. These include dioxazine purple mixed with white and yellow oxide, as well as touches of permanent light violet, burnt sienna and Payne's gray.

EDGES

When painting clouds, especially those seen against a blue sky, it is very easy to make them seem too precisely articulated. When a cloud is in the shade, the colors—the gray shadow and the blue sky—are closer in tone and the edge of the cloud will not be distinct. In watercolor these colors could be applied wet-in-wet; in opaque paints they could be blended together. When the top highlight of the cloud is seen against the blue sky, however, the edge of the cloud can be seen clearly. In watercolor you might apply the blue around the cloud shape and leave the white paper for the highlight, wet on dry. Always be aware of your edges, varying them not just for pictorial accuracy but also to add interest to your skies.

▼ *In this picture, the white highlights of the clouds stand out strongly against a dark blue sky. It is interesting to observe how the small wispy clouds have soft edges and the larger cloud masses have a more defined edge, which makes more obvious shapes.*

Softer edges can be lifted out with a tissue if painting in watercolor.

Harder edges in the distance must not be too stark.

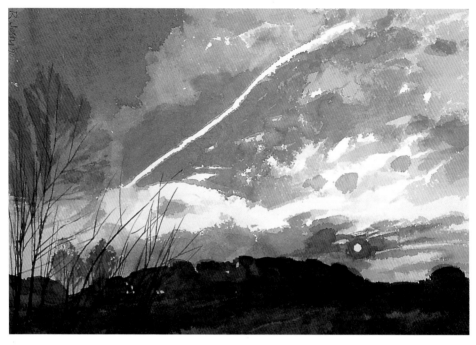

▲ Ronald Jesty, Sunrise with vapor trail, watercolor. The artist had to plan where the white shapes would appear before applying any washes. Having applied a pale wash of ultramarine, carefully working around the white diagonal vapor trail, another stronger wash of blue was added, wet-in-wet, to strengthen the contrast around the line and the low, white cloud shapes.

You could reserve the vapor trail with masking fluid.

Overhead clouds with crisper edges, wet-on-dry.

Use the texture of the paper for a broken edge.

INTEGRATING SKY AND LANDSCAPE

Having satisfactorily developed your skies, you may now find that what troubles you is integrating the landscape below with the sky above. First of all, the landscape often helps you with elements straddling both parts—usually trees—crossing the horizon and forming a link. You can also help combine the two with similar brushwork. Repeating landscape shapes in the clouds helps to take the eye from one to the other, too. Touches of the same color in both areas do likewise. Otherwise, with opaque paints, try painting on a tinted ground, leaving small patches of it showing through the paint across the picture surface. This will unite all parts of your painting.

▼ *In this evening scene, the silhouetted shapes of bare trees knit the land and sky together. Intermittent glimpses of the bright horizon are broken up by the very dark tree forms, helping to merge the two areas even more effectively.*

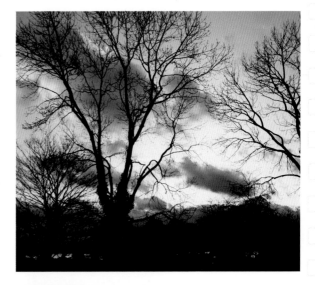

A screen of trees will naturally link sky and landscape.

A deep golden tinted ground allowed to break through would tie sky and landscape together.

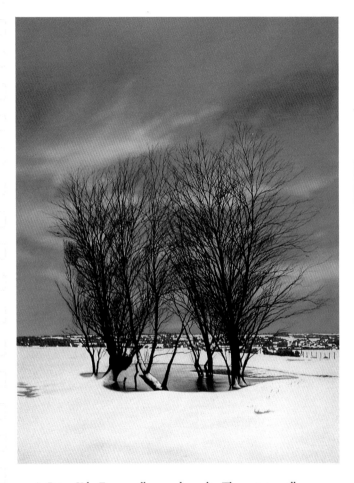

The trees cross from landscape to sky and tie them together.

The bare twigs are woven into the sky horizontals.

▲ Brian Yale, Frozen willow pond, acrylic. These winter willow trees form a strong link between the brilliant white landscape and the cold blue sky, in exactly the same way as the trees in the photograph. Although the horizon is clearly visible in the painting, the distant suggestion of dark woods has been painted in the same tone as the near-black trees, so making a link with the vertical shapes.

DRAMATIC SKIES

Looking through this book you will find plenty of skies that are dramatic, colorful or just plain impressive. But there are those freaks of nature which come under no one category and yet are part of the celestial repertory. Rainbows and lightning are guaranteed to give you a thrill but certain combinations of weather and light can defy the imagination. The artist can have trouble expressing such contortions of light. The secret is to understate what nature takes pleasure in shouting about.

◀ *These dramatic beams of sunlight were created once the dark gray cloud washes were dry. Using a stiff, slightly damp brush, horizontal lines were scrubbed out of the underlying wash.*

▲ *While the dark cloud washes of Payne's gray were still wet, a wash of very dilute yellow ocher was applied below the gray, causing the colors to bleed. This wet-in-wet effect created a very effective 'burst' of light.*

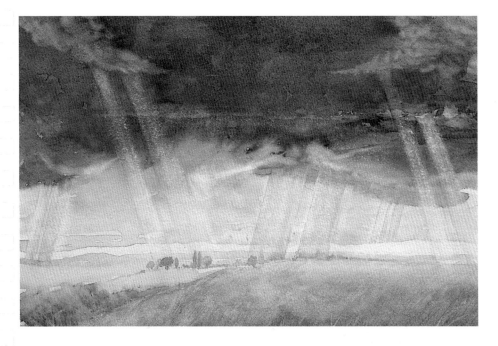

▲ *Doreen Bartlett, Storm cloud, watercolor. The artist makes the shafts of sunlight breaking through the heavy storm clouds an integral part of the composition.*

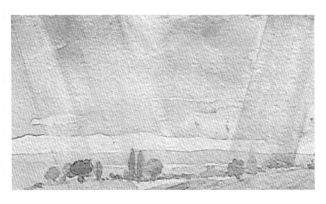

◀ *The slanting washes of pale gray rain mirror the beams of slanting sunlight, balancing the composition. Notice how a strip of white paper has been allowed to show along the horizon to give the impression of distance.*

RAINBOWS

Rainbows never fail to delight but they are hard to paint as, in reality, the colors are transparent. Often the attraction of a rainbow is the contrast it makes with a sudden storm. The rainbow can often be seen against a dark stormy sky, presenting itself as an optimistic token of weather to come and a reminder that the sun is still there, even if you cannot see it. When painting, try to hint at the atmospheric nature of this phenomenon. With opaque paints, add the rainbow to the sky towards the end of the painting in soft veils of palest color. With watercolor, use pale washes, controlling the area to be colored by allowing the previous washes to dry first and only wetting where you want the color to spread. Keep a tissue handy to help control the color.

▼ *This rainbow is firmly placed in the picture space by the fact that the church steeple overlaps it. Take care not to make the colors of the rainbow too bright. With opaque paints it is easy to knock them back with white paint if they are. With watercolor, try washing the whole sheet (only if good quality) in cold running water to reduce color potency.*

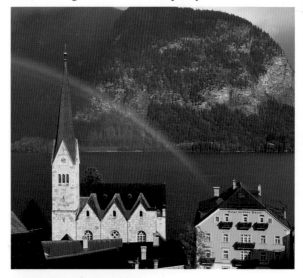

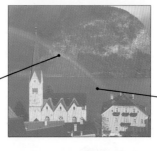

Note how the colors are transparent and the landscape can be seen through them.

The edges of the rainbow blend into the background.

Using gum arabic

1 Float in Payne's gray and Antwerp blue over a dry wash of pale yellow. Lift off the rainbow area.

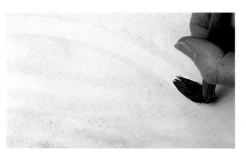

2 Now you can start adding the rainbow colors.

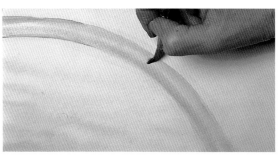

3 Wet the rainbow and paint with a fine brush. Paint each color carefully and wipe down with a tissue if the color spreads too far.

4 Wet the sky area and feed in dilute Payne's gray mixed with gum arabic. Clean off the rainbow with a damp brush.

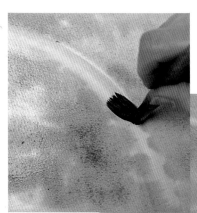

LIGHTNING

The drama and clamor of a raging storm is epitomized by the sight of lightning striations across a dark sky. Such a flash is difficult to see in the split second it appears and this impression of sudden light, complete with a crash of thunder, has to be put across in your painting. Photographs of lightning show the forked shapes and different types of color. When painting, however, it is a case of taking artistic licence and exaggerating the luminosity with a spread of light from the forks and with added points of color to syncopate the flash of light. With water-based paints, reserve the lightning with masking fluid or wax. Here a little white body color is added to watercolor to give more opaque washes.

▼ *Lightning dances across the sky in exaggerated leaps with foreground streaks brighter and those in the distance less defined. Note how it lights up the sky and the falling rain acts as a dramatic background to the dark shape of the foreground landscape.*

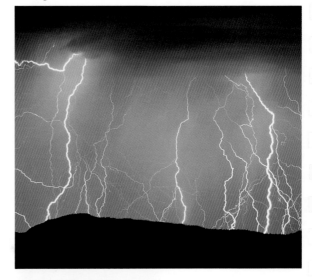

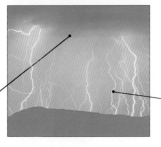

Clouds and rain are lit up creating interesting gradations of tone.

Foreground lightning is brighter and more defined.

Wax resist

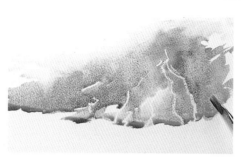

1 With a white candle sharpened to a point, draw in the lightning. Wet the sky area and, starting from the top, feed in grays.

2 Add darker grays on the skyline wet-in-wet. Note how the coarse texture of the paper breaks up the washes.

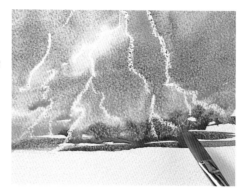

3 Leave white areas in the landscape to suggest the lightning illuminating the landscape.

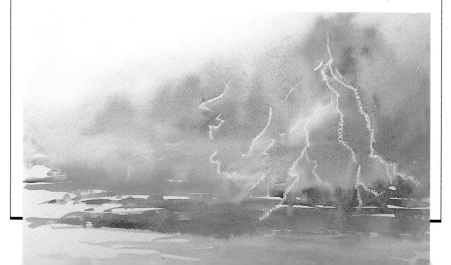

CREDITS

Quarto would like to thank all the artists who have kindly allowed us to reproduce their work in this book.

We would also like to thank the following artists for their help in the demonstrations of techniques: Jean Canter, David Carr, Patrick Cullen, Margaret Glass, Ted Gould, Paul Kenny, Kay Ohsten, Alan Oliver, Ian Sidaway.

Senior art editor Clare Baggaley
Designer James Lawrence
Design assistant Steve Tse
Editor Cathy Marriott
Copy editor Diana Craig
Photographer Colin Bowling
Illustrator Neil Ballpit
Picture researcher Miriam Hyman
Picture research manager Giulia Hetherington
Art director Moira Clinch
Assistant art director Penny Cobb
Editorial director Mark Dartford

Photographic credits

Key: a above, b below, c centre, l left, r right
Moira Clinch 9al, cl; 54
John Hyman 6a; 50; 56
Pictor International 60, 62
Windrush Photos 5bl, c, r; 7al, ar; 8ar, cl, br; 9cr, br; 48; 52

Typeset by Central Southern Typesetters, Eastbourne
Manufactured by Bright Arts Pte Ltd, Singapore
Printed by Leefung-Asco Printers Ltd, China